DRAWING PEOPLE

The Diagram Group

BROCKHAMPTON
DIAGRAM
GUIDES

Drawing People

First published in Great Britain in 1997 by
Brockhampton Press Ltd
20 Bloomsbury Street
London
WC1 2QA
a member of the Hodder Headline Group PLC

ISBN 1-86019-811-2

Also in this series:
Boxing Skills
Calligraphy
Card Games
Chinese Astrology
How the Body Works
Identifying Architecture
Kings and Queens of Britain
Magic Tricks
Origami
Party Games
Pub Games
SAS Survival Skills
Soccer Skills
Understanding Heraldry
World History

Introduction

Drawing People offers a simple and straightforward approach to drawing, with advice on which tools and techniques to use, the best places to draw, and how to keep a sketchbook. You will be shown how to construct the human form, how to draw faces, hands and feet, and how to add movement and character to your drawings. Using this book, anyone can learn how to draw people.

Contents

Getting ready to draw

Before you start to draw you will need to collect together some simple equipment. Pencils, pens, crayons and chalks are best for drawing and you will need to practise with them to decide which suits you best. You will also need to choose some paper which comes in a range of thicknesses and textures.

PENCILS

Working with pencils

When you are drawing, the pencil acts as an extension of your finger, your hand, or even your arm, following the movement made by your muscles. The way in which you hold the pencil will determine the kind of lines that you can produce.

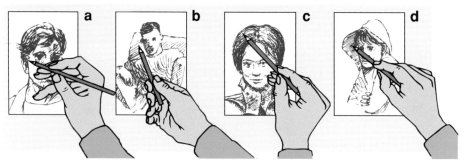

a In the writing position the pencil is held close to the tip, and the hand is rested on the paper. This gives maximum control over fine detail.

b The sketching position gives more freedom; the pencil is held near the end, with the fingers curling toward the palm.

c The pencil can be held near the end with the fingers pointing along the shaft; this position does not allow a great deal of control.

d If the pencil is held with the first finger along the shaft, this gives good control for exerting gentle or firm pressure for different weights of line.

Pencil grades

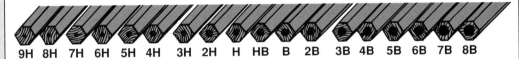

9H 8H 7H 6H 5H 4H 3H 2H H HB B 2B 3B 4B 5B 6B 7B 8B

Pencils are the most common drawing tools, and have been in use for several hundred years. They are easy to draw with and marks can be altered using an eraser. These days leads are made from graphite, usually encased in wood. The hardness and thickness of the lead determines the pencil's grade: 9H is the hardest, 8B the softest. Hard pencils range from 9H to 4H; they are used for extremely accurate plans and drawings. Medium grades are 3H to 2B; these are the most commonly used pencils. Soft grades range from 3B to 8B.

PENS

There are many different types of pen. Ballpoints and felt tips are excellent for sketching because they give immediate and permanent results. The exact marks made by a pen depend on the nib, ink and paper chosen, and on the direction and pressure of the stroke used.

In this pen and ink drawing the flow of garments has been captured using a traditional pen. Downward strokes or strokes made with hard pressure produce thick lines; across strokes or strokes made with thin pressure produce thin lines.

Charcoal and graphite

a Natural charcoal is made from charred willow, beech or vine. The sticks are brittle, difficult to handle, and unsuitable for detailed work.

b A charcoal pencil is less messy but is also less versatile.

c A graphite pencil is best suited for outdoor sketching.

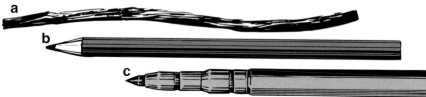

Pastels, chalks and crayons

These are available with chalk, oil, or wax bases, in three grades (soft, medium and hard) and over 600 shades. The paper covers protect your fingers.

d Pastel stick
e Pastel pencil
f Chalk
g Chalk holder
h Conté crayon
i Wax crayon

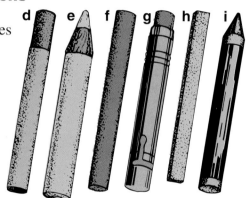

Working with charcoal, chalks and pastels

- Use the point of the charcoal or crayon to produce fine lines. The point can be kept sharp using a piece of sandpaper.
- Use the side for creating large areas of tone.
- Use your finger to soften lines. This is especially effective when creating shadows.
- Use a putty rubber to dab at the work to make corrections, pick out highlights, or soften lines.
- If you need to add highlights in dark areas, use white chalk or crayon.
- Highlights can also be created by removing colour, but this requires practice.

Pens, ballpoints, felt tips

a The traditional pen uses a wide selection of nibs to produce a rich variety of lines of differing thicknesses.

b A mapping pen is a variation on the traditional steel-nibbed pen. The finer range of nibs makes it useful for small detail work.

c A fountain pen can be useful for sketching outdoors.

d A ballpoint pen can be used for sketching, but can produce blotchy, inconsistent lines.

e Felt tip pens are available in a wide variety of thicknesses, colours and degrees of hardness. The top must be replaced or the pen will dry out.

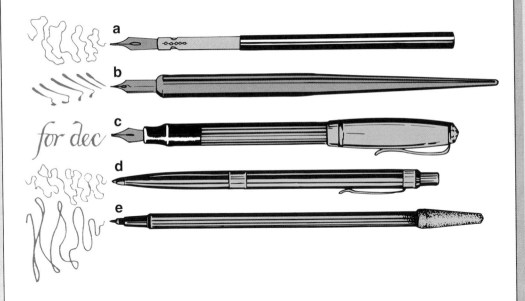

CHALKS

These drawing tools can be used to make a wide range of marks, and are especially useful for adding tone or when working on a dark-toned paper. Use a rough-textured paper to capture all the particles of colour. Handle the surface carefully to prevent smudging.

THE DRAWING SURFACE

It is important that you choose the right paper for the materials you are using to draw with as an inappropriate paper can cause bad results. For example, pen nibs can catch on rough paper, or tear through thin paper; ink might soak through thin paper onto the next page.

Types of paper

- Coarse-grained paper is usually thick with a regular surface texture that is best used with chalk, crayon, or pastel but not with pen.
- Normal cartridge paper is available in sheets and in sketchbooks. It is the most common and the most versatile surface for drawing on because it is strong and takes smudging and erasing well.
- Fine detail paper is best for pens but tears easily. It is great for outdoor sketching.
- Tracing paper is used for copying over previous drawings and is smooth enough for use with pencil and pen. Its grey colour makes it unsuitable for finished drawings.

Tips for using tools and equipment

- Always keep your work surface clean.
- Discard old pencils, pens and crayons.
- Don't be seduced into buying expensive tools. Great drawings can be produced using simple, inexpensive equipment.
- Never sharpen pencils over your work.
- Store your pens and pencils together, upright in a jar or similar container.
- Store paper flat.
- When you are drawing, protect your work by resting your hand on a piece of paper.
- Cover your work whenever you take a break.

Drawing indoors

Shown here are some basics about working at a desk:
1 If right-handed, your source of light should come from the front and left.
2 Use a steady drawing board raised slightly on blocks to prevent you leaning over too far.
3 Leave space at the side of your drawing area on which to place pens, etc.
4 Keep jars and other drawing tool holders within easy reach.
5 Keep a box or set of drawers handy for storing tools and small objects.
6 Make sure you have a comfortable chair with a back-rest.
7 Arrange an area where you can keep your drawings flat.

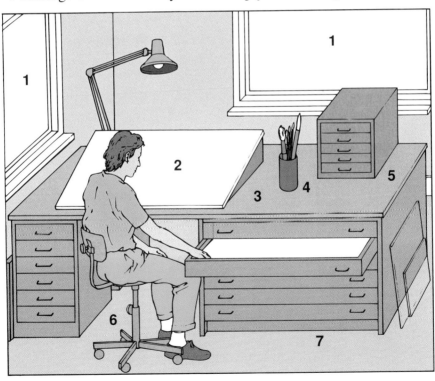

Drawing outdoors

Sketching outside is exciting and valuable. Selecting subjects, collecting information and impressions, filling sketchbooks with experiences and observations – all this helps your study of reality, which is the heart of drawing. Make sure you will be comfortable. You may sit or stand for long periods, so take warm clothing, or, in the heat, wear a hat or perch in the shade. Take along a shoulder bag to hold your favourite pencils, pens, ink and sketchbook. Don't give room to untried tools. In a wind, secure your paper firmly to a board. Keep alert for colourful atmosphere, interesting characters or crowds; sketch your general impressions and all intriguing details.

How far from the subject?
Leonardo da Vinci said: 'When you have to draw from nature, stand at a distance equal to three times the size of the object you wish to draw.'

Your choice of site at which to draw will be governed by factors such as composition, the aim of your drawing, or how long you can observe the people you are drawing. Try to put yourself 6m from your subjects, your drawing surface 50cm from your eyes, and record a 2m-high object 16cm on the paper.

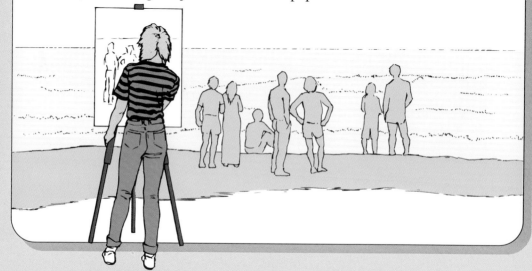

Where you sit

You can usually find somewhere to stand or sit so that you are in a fixed position for looking at your subject; but without a moveable seat you may be limited in your choice of view because of the lack of a suitable place to sit.

a Sit on a wall or tree or any comfortable perch.

b Carry a small collapsible stool or chair.

c For careful work take a light portable easel. It may be difficult to handle in wind, however.

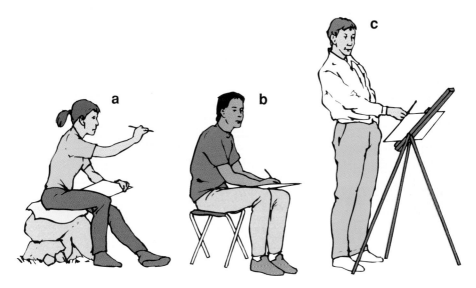

Remember, you get out only what you put in, so spend time observing people. Don't be put off by onlookers. Only you can truly judge what you draw; you can never do a bad drawing, only one that doesn't quite catch what you intend.

Never despair. Work with care.

Drawing is fun.

Keeping a sketchbook

Sketching people presents one particular problem – they move. Unless you are deliberately sketching people in action, try to pick subjects who are in fairly static poses – lying down, sitting down, waiting for something or someone – or who are preoccupied with another activity – reading, for example, or watching television. They are then likely to remain in the same position long enough for you to capture their pose.

When you sketch action figures, concentrate on the general shapes and the basic movements of the forms, and forget the detail. Each sketch should capture the moment. These incomplete sketches will all contribute to your total view of how people place and move their bodies.

Court rooms, waiting rooms, libraries and churches are all good places to study people. If the person you are studying moves away or changes position, switch your attention to another subject. Put together, your studies will help you recreate the characters of the figures.

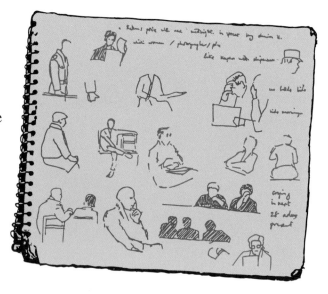

Other places to sketch people are in shopping malls, in cafes and restaurants, at the theatre and in parks.

If you are attending art
classes, take a break now
and then to observe
your fellow students.

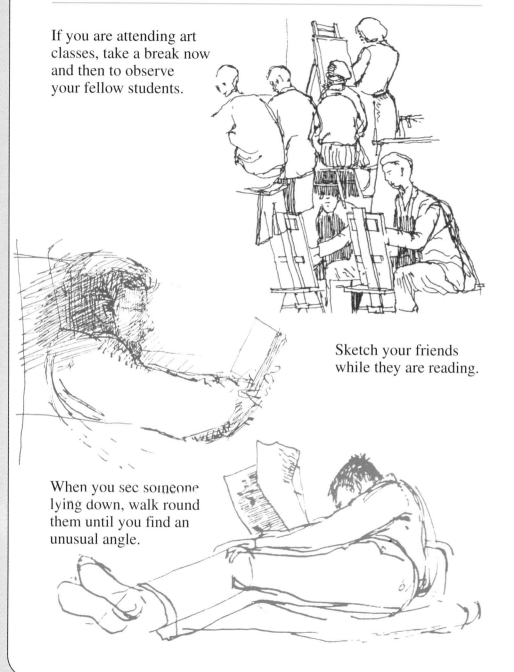

Sketch your friends
while they are reading.

When you see someone
lying down, walk round
them until you find an
unusual angle.

The human form

We normally see the human figure clothed. Drawing the nude can usually be done only in art school or from sculptures or photographs. Nevertheless an understanding of the basic forms of the body helps enormously when drawing clothed figures. Most people are afraid of drawing the human body because the result can too often reveal mistakes or misunderstandings. After all, everyone knows what a human being looks like. So when you start, establish the chief elements and don't be confused by distortions which are the result of your own particular view point.

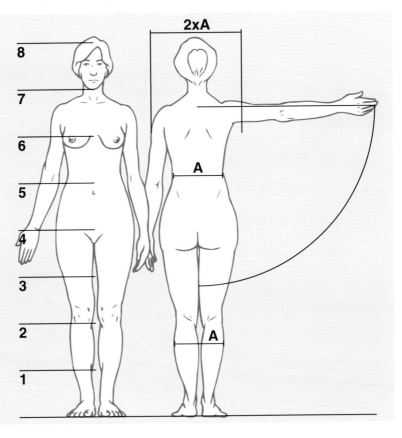

Try to see the basic proportions under the clothes. Always attempt
the hard forms – hands, face, feet. It is by mastering the difficult
elements of the human figure that we gain confidence. See all of
the figure, all the time. Don't just draw bits.

BASIC HUMAN PROPORTIONS

Every body conforms to certain basic interrelated proportions; for
example, shoulder width to length of head. Shapes vary – fat, thin,
tall, short – but recognising major relationships helps you to draw
well.

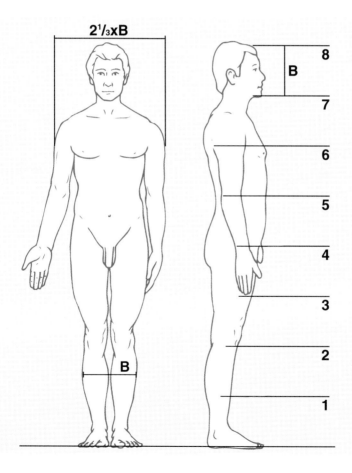

The human body is basically symmetrical, and if a vertical line is drawn through the centre of an upright figure, the two sides should be balanced, except perhaps for the limbs; if one leg is thrust forward, the other leg will be put back. You should always be aware of this balance in your drawings.

Constructing a figure

1 When planning the form, first consider a rectangle: choose the height, and divide it into 8 equal sections; the width will be $2^1/_3$ times $^1/_8$ of the height. Draw diagonals within this rectangle. You now have most key points for completing the detail.

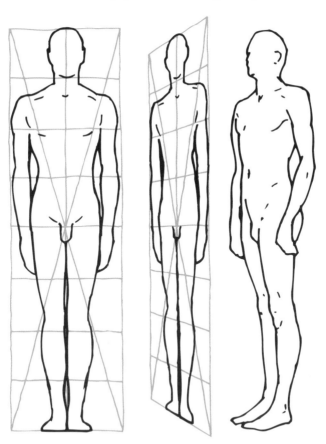

2 The grid intersections on your figure will remain, whatever your view point, although if the figure is drawn turning away remember that the horizontals will converge in the distance. Set into your framework a two-dimensional, flat plan of the figure.

3 Finally, build up the smaller forms, using the grid and keeping the proportions correct.

The moving figure

Balance and tensions influence the position of the limbs. Remember all the horizontal relationships and check each side of your vertical central line.

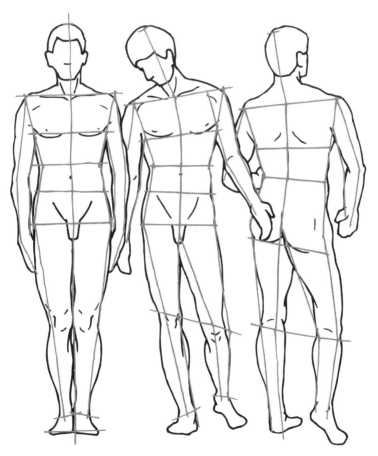

CHANGING YOUR VIEWPOINT

If you want to draw a receding, reclining figure, or one seen from
an unusual angle:

1. First construct a four-sided frame, remembering to taper the
 lines to the distance.
2. Draw in the diagonal, then divide the frame into 8 equal,
 transverse sections.
3. Set your figure in the grid.

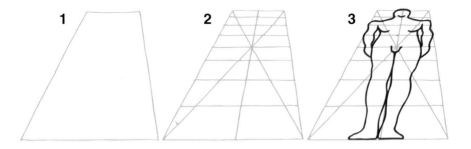

The human figure
fills space, and its
torso and limbs are
rounded. Imagine the
body as a space suit
made up of bands. To
create volume,
imagine a cage into
which your human
form fits. Always try
to see the figure in
the round. The torso
is like a tree trunk
and its limbs like
branches.

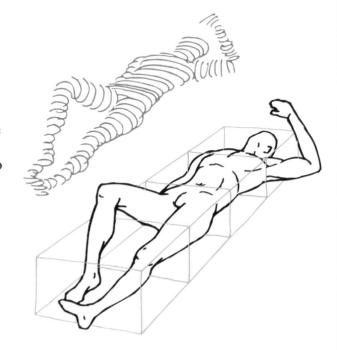

Drawing heads

Drawing heads is notoriously difficult. If you use yourself as a subject, you can get plenty of practice on a constant model that can be re-examined whenever you choose. Think of your self-portraits as explorations in drawing, and forget about other people's opinions of them as likenesses.

Whether you draw yourself or someone else, you will need to observe all the details of the head very closely, as well as understanding its basic construction. Pay special attention to the relationship between the different parts of the head as it is the careful measuring of these points that makes for accurate drawing.

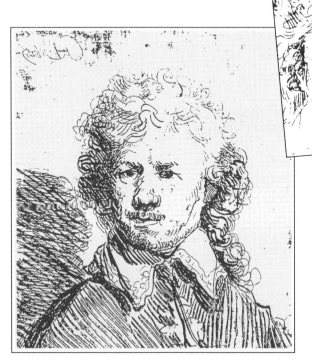

These self-portraits show Rembrandt at 27 (left) and 45 (above). He used his self-portraits as a testing ground for his ideas, exploring expressions and lighting by using his own head as a model.

Constructing a head

It is often easier to understand the head's structure by thinking of it as interlocking geometrical forms. As a simple exercise, try this ball and bucket construction.

1 Draw a ball. Draw three lines around the ball as shown.
2 Add a bucket to the bottom of the ball and extend two of the lines from the ball onto the bucket as shown.
3 Draw a circle on the side of the ball at a point where the lines on the ball cross.

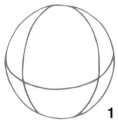

4 Remove the circular side segments. You have a basic construction for a head.
5 Use the central vertical line to plot the position of features.
6 Add the features and complete the head.
7, 8, 9 The geometrical construction remains the same whatever the angle of the head.

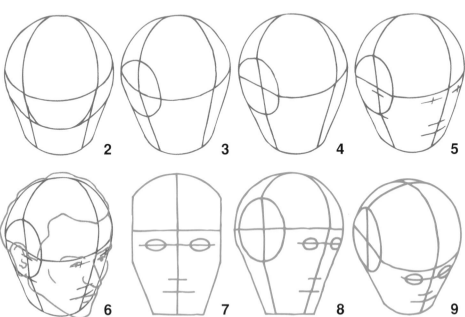

Once you have mastered how to draw a head you can practise drawing it from different angles.

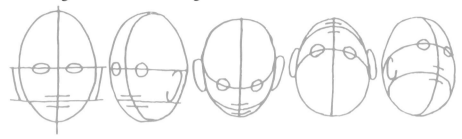

Some people find it easier to imagine the head as a square block rather than as a ball and bucket.

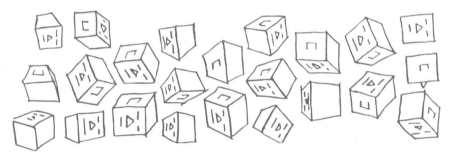

Drawing faces

Whatever we look like, our features – the eyes, ears, nose, and so on – are in the same proportional relationship. A thin face and a fat face both have underlying skulls that determine these proportions. In order to draw heads well, you need to understand this underlying structure and the relationships between the features. You need to draw what is really there, not what you think is there: careful observation and checking is what counts when you are drawing a head.

However, it is important that you do not let your understanding of the framework interfere with the feeling and quality of your drawing.

Face proportions

This exercise will help you to discover the proportions of your face. First draw an oval to represent your face, and divide it in half with a vertical line (**a**). Use a pencil to measure the distance from the base of your chin to your eye (**b**). Place a hand on the top of your head to establish the top of your skull, and measure the distance from your hand to your eye (**c**).

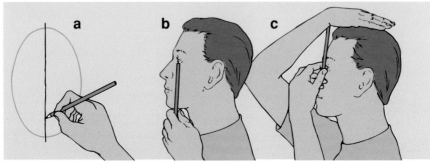

If you plot these distances to scale on your oval, you will find that you have drawn your eye halfway up the centre line (**d**). If you continue to work out the relationship between your features, you will find the following: measuring up from your chin, your nose is $1/4$ of the way up the centre line (**e**); measuring down from your nose, your mouth is about $1/3$ of the distance between your nose and your chin (**f**); the width of your eye is equal to the distance that your eyes are apart (**g**); the tops of your ears align with your eyes and the bottoms of your ears align with the space between your nose and your chin (**h**).

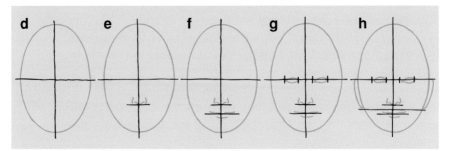

Practise drawing faces whenever you can. These fishermen have
weather-worn skin and the heavy eyes suggest short periods of
sleep.

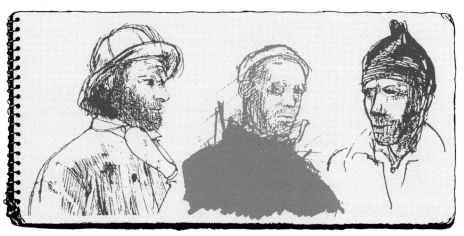

An ideal opportunity to study faces is when friends and family are
asleep. That way you can really observe the detail, like the stubble
on this man's chin.

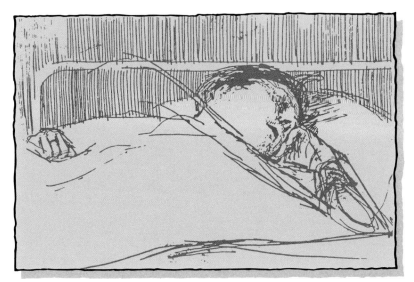

Drawing expressions

Facial expressions reveal our thoughts. The muscles of the face are contracted with our emotional responses. Artists enjoy adding expressions to a drawing because they project to the reader the subject's thoughts.

Sit in front of the mirror and express different emotions. See how your face changes with each new expression. Notice what happens to your eyes, your nose, your mouth, your cheeks and to the wrinkles in your skin.

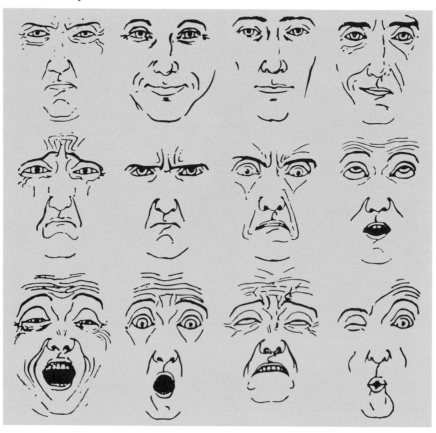

Look through magazines to find people with different expressions. Do they have anything in common? Try to capture expressions when you are drawing people.

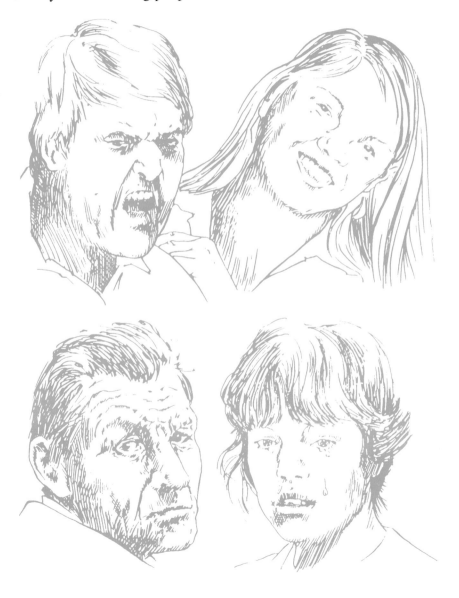

Drawing hands

Hands are notoriously difficult to draw but practice is the answer –
always complete the hands in your figure studies. Imagine the
flexibility of the individual fingers and remember their basic flat
shapes when you look a them from different or unusual viewpoints,
or when the fingers are curled up and the underlying relationships
hidden.

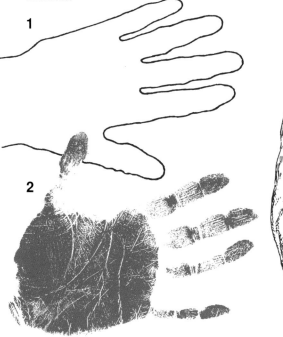

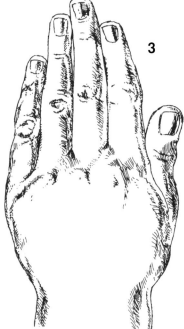

Drawing your hand

1 Draw around your hand to
produce an outline which
shows the variable finger
lengths.
2 Make a print by pressing
your hand on an inky pad
and then transferring the
impression to paper. This
reveals the basic parts of the
fingers and the shape of the
palm.
3 Rest your hand palm down
and draw it, measuring the
separate parts.

4 and **5** Points to notice:
a Variable length of fingers
b Variable position of joints
c Directions of fingers
d The broadest part
e The thickest part

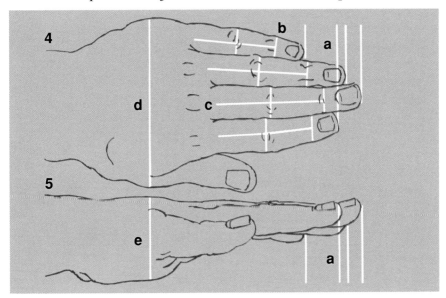

Studies of hands

Fill pages of your sketchbook with studies of hands. Draw from photographs, copy hands from other artists' work, and sketch your free hand in the mirror doing a range of tasks. With experience, you will be able to draw imaginary hands doing whatever you require of them.

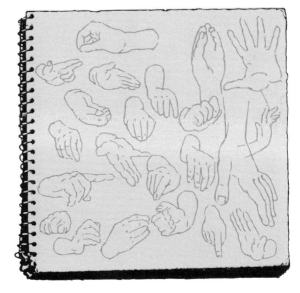

Drawing legs and feet

A person's legs are normally identical but may appear dissimilar because of the different amounts of weight carried by each limb, so notice the dissimilarities and recognise the reasons for them. Bare feet are seen infrequently but a knowledge of their characteristics will help you put your figures firmly on the ground or floor and establish their bases. Try studying and sketching legs and feet from photographs, statues, and drawings and paintings by artists.

Look where the muscles curve round to the other side of the leg (**a**). In your drawings curves help to indicate the roundness of a limb. Notice the firm patches where bones are just under the skin (**b**), at knees and ankles; these are useful checking points.

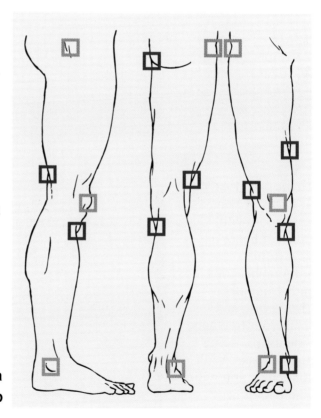

☐ a
☐ b

The human foot

These studies are based on measured drawings by the 16th-century German artist Albrecht Dürer. Points to notice:

- **a** The widest point
- **b** Directions of toes
- **c** Hollowness under the centre
- **d** The weight-bearing point
- **e** The proportion of width to length

The foot lacks the flexibility of the hand so, if you remember the underlying structure, you are more likely to draw feet correctly. The appearance of the feet will probably alter with a change in viewpoint rather than because of a new position.

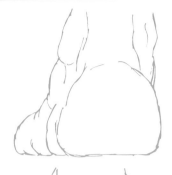

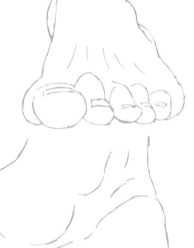

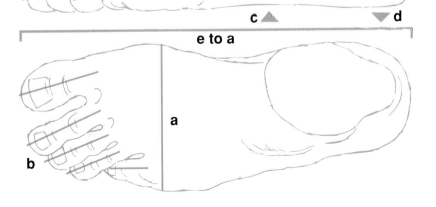

Drawing movement

The changing positions of moving figures mean you must sketch quickly. When drawing movement and people in action, recognise and keep in your mind an after-image of the main shapes. Try to capture their balance, stance and gesture. Do not worry about fine detail. It may be necessary to keep several drawings going simultaneously.

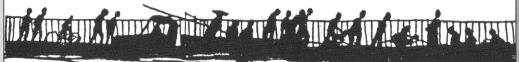

In the short time available, this drawing has caught the forward-leaning stance of the hurrying figures.

Drawing silhouettes is an easy exercise that will train your eye to represent shapes accurately. By concentrating on the outline you will learn to cut out distracting details and also gain confidence in your own skills. Practise drawing people in action or try drawing silhouettes from photographs in books and magazines like those drawn here.

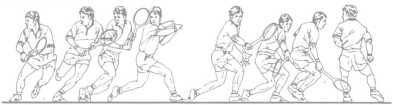

The professional illustrator used many different photographs to draw this sequence which shows how to hit a backhand in tennis. Drawing such action figures needs very good reference material and considerable experience.

Good drawings possess movement within their compositions. This is because the eye, after absorbing an overall impression, then moves around the picture following the lines of structure. In this way the observer is involved in the inner space, almost as if he or she had become part of the subject.

Creating movement

First trace separately two figures from a photograph (**a**); then put the figures in a series of different relationships. By enlarging or reducing the figures you can make them appear to be in separate planes (**b, c, d**).

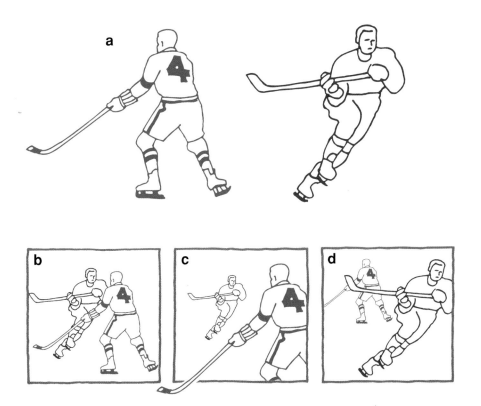

Using light and shade

Varied and interesting results come from changing the direction of light falling on people and their surroundings. Ask one of your friends to sit for you, and before you start your drawing, take time to consider the particular effects of the light source, and study the consequences of moving first the sitter and then the light. Experiment by drawing with a light-coloured chalk on dark paper, working from the highlights into the dark area.

In these sketches (left) the head was the same, but the light source was changed in order to see what sort of effect this produced.

a Light from above enables you to quickly identify forms of the face.

b Side light may produce dark areas which obscure detail.

c Light from below is good only for theatrical effects.

Practise lighting faces

Put a sheet of tracing paper over each of these outline faces and imagine where the light would fall by following the direction of light indicated by the black arrows.

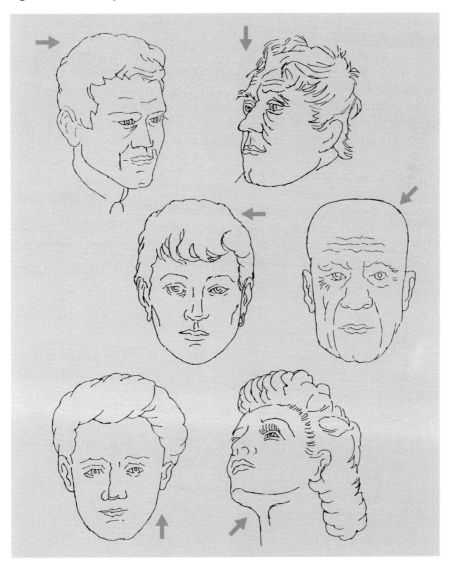

Improving your accuracy

Many people feel that their drawings are not quite accurate, that the shapes and sizes are somehow wrong. To draw is to transfer what you see onto the paper in front of you, but the eye is easily deceived.

There are a number of simple techniques and checking devices that you can use to make sure that you draw what is actually there, not what you think you see. Try to position your subject in the centre of your field of vision – widening your field of vision unnecessarily only increases the possibility of inaccuracy.

Parallel positioning

How you stand in relationship to your subject is very important. Your subject should be as close to parallel as possible, so that you can just flick your eyes from subject to paper.

a Poor position: the head must turn each time a line is drawn.
b Correct position: the head can remain still while the artist is drawing.

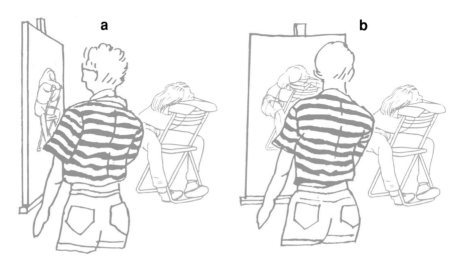

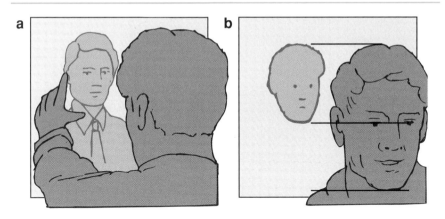

Check what you see

Objects are not necessarily the size we think they are. For example, what size is your reflection in the mirror? Look in a mirror and estimate the size, then use a wax crayon to actually draw the outline of your face on the mirror's surface (**a**).When you measure it, you will find that the outline you have drawn is half the size of your head (**b**), although most people would have expected it to be the same size. The eye has seen what it believed to be there: the optical image that is the same size as your head is as far behind the mirror as you are in front of the mirror (**c**), not on the mirror surface itself.

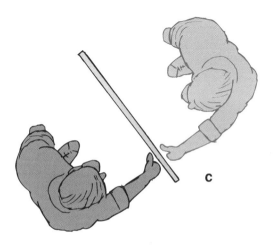

© DIAGRAM

Checking devices

Most artists use some form of checking device to help them test
their judgement of horizontals, verticals and angles. A plumb line
(**a**) is a simple device for checking vertical alignments, while a
pencil held out horizontally (**b**) can be used to check distances
across. If you have a composition that includes a number of
difficult features (**c**) you can check it through a right-angled frame
marked out to show distances. View the object through the frame
(**d**) and note down where the points touch the edges of the frame.

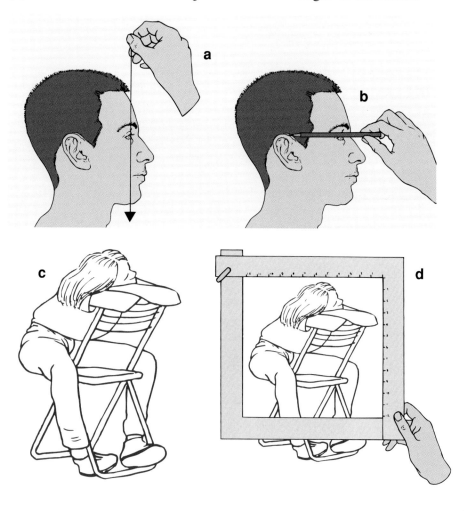

Using a grid

The most direct way to transfer shapes accurately is to stand your subject in front of a grid (**a**). You then record the irregular shapes against a similar grid drawn on your paper (**b**), working through square by square. Artists very often sketch on graph paper as the accurate grid helps to guide their judgement of shapes and sizes.

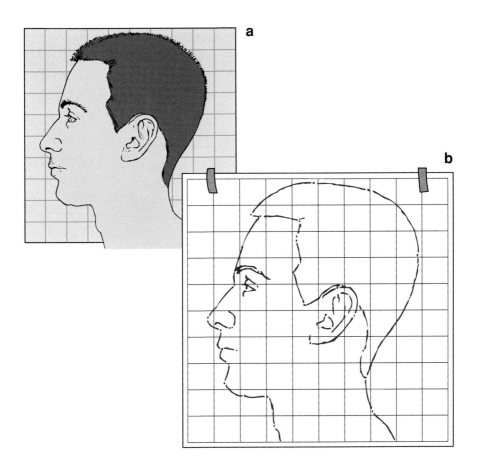

a

b

Placing the ear

You can use the relative proportions of the features to help you
place the ear correctly when you are drawing a head from the side.
First check the proportions on your own head. Your eyes occur
halfway up your head and the top of your ear is on the same level
as the centre of your eye (**a**). Measure the distance from your eye to
your chin (**b**) and compare it with the distance from your eye to
your ear (**c**). You will find that the distances are the same. You can
then use this principle – that the distance from chin to eye equals
the distance from eye to ear – to draw your subject's ear in the
correct place. Study your subject carefully and sketch in the profile.
Measure the distance from eye to chin on your drawing (**d**), then
plot the same distance back into the head (**e**). You will then have
established the position of the ear. The triangle formed by joining
the ear, eye, and chin is very helpful in establishing the central
areas of the side view (**f**).

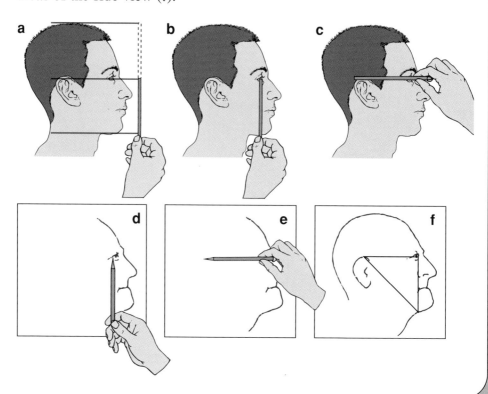

Drawing hair

The surface of the human head can be smooth, as with a new baby, or covered with hair. Hairstyles are the most characteristic features of a person. Hair can be wild, fuzzy, bush-like or smooth and glossy. Collect examples of different hair styles and textures from magazines. Copy the heads here and draw a strong hairstyle from a picture you have found onto them.

Drawing cartoons and caricatures

A funny drawing is a realistic drawing showing people in funny situations or doing funny things. A caricature is an exaggeration of a realistic likeness to reveal, suggest or emphasise foibles, characteristics, attitudes and behaviour.

Caricatures range from the unflattering to the evil and ugly, and are usually drawn of actual people in the public eye: politicians, entertainers, royalty, media stars and sportspeople.
Drawing skills and creative interpretation are vital for successful caricaturing.

Examples of caricature　　　　　　**a cartoon**

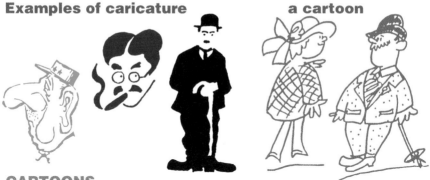

CARTOONS

A cartoon is a few simple lines presenting the idea of a person. No advanced drawing skills are necessary. The conventions of drawing cartoons can be learnt by anyone who can hold a pencil. An ability to draw realistically can be a stumbling block for successful cartooning because of a tendency to add too many embellishments.

A sense of humour is essential: the quirkier, the better.
An open mind, fascinated with all the facets of humanity, is the breeding ground for great cartoons.

Basic conventions for cartoon drawing
Simplicity, expression and movement are combined to create an
illusion. The best drawing tool is a fine felt- or fibre-tipped pen
which gives a good black line. Also these types of pen tend to be
easier to manage than ballpoints, which give finer, more wiry lines.
It is a good idea to begin with faces. A face is drawn in the
following way:
 1 The nose, a hooked line facing left or right
 2 The eyes, two small scribbled dots on the nose
 3 The mouth, a slightly wobbly line
 4 Then the face shape, hair and ear
 5 Finally, eyebrows are added if they will make the basic
 expression more friendly, miserable, puzzled, etc.

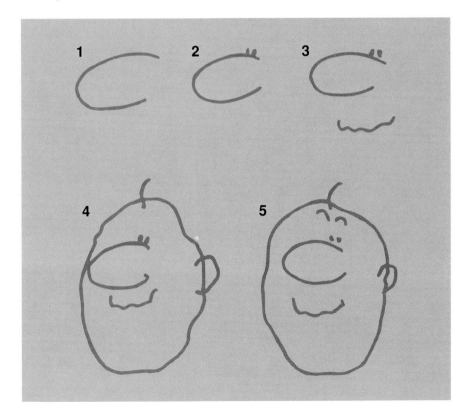

Whole body cartoons

Bodies are usually quite out of proportion to the head and are often on the move.

A knowledge of anatomy is not necessary, as clothes cover most cartoon bodies, and only a suggestion of body shape is necessary. Hands have only three fingers: fourth fingers are unnecessary details.

The conventionally suited man can be drawn in stages:

 1 Head and neck
 2 V-shaped collar and tie
 3 Jacket lapels
 4 Jacket with arms and hands
 5 Trousers with shoes (everyone develops their own drawing style for footwear).

A shadow fixes him to the ground.

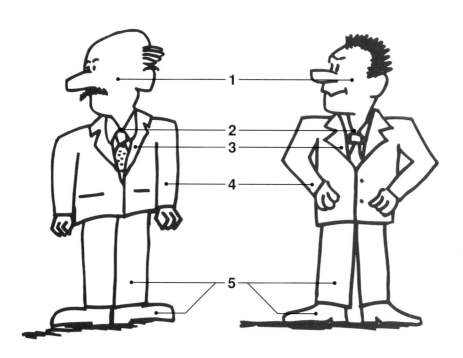

Diversity

There are three factors which interrelate a drawing: the subject's personality, the artist's skills and the medium. Although the basic elements of a head are common to all humans, the various combinations of minor differences of features are infinite. People come in all shapes and sizes, colours and textures. Studying people offers you an enormous variety of subjects.

The artist's view of the subject is the consequence of education, social norms and personal reactions. The artist's skills are a result of self-training and instruction.

The medium very strongly influences the end result. A drawing of a person on a notepad, bank note, memorial plate, medical chart, satirical cartoon – each describes a person in a different way. These two pages contain twenty examples of the wide variety of ways of describing the human head.

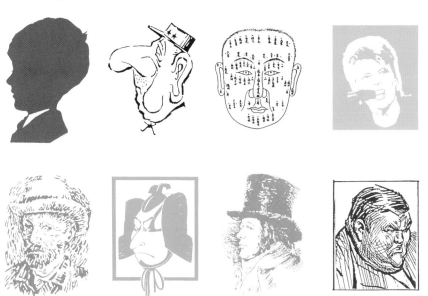

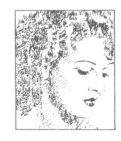
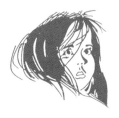

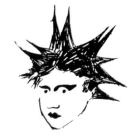
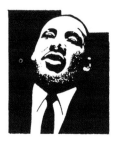

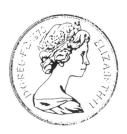